how artists see
ANIMALS

SECOND EDITION

COLLEEN CARROLL

ABBEVILLE KIDS
A DIVISION OF ABBEVILLE PRESS
NEW YORK · LONDON

Painters understand nature and love her
and teach us to see her.
—Vincent van Gogh

This book is dedicated to my favorite little animal lovers: Gabriel, Zak, Lacey, Chloe,
Forrest, Benny, Corey, Kylie, Adelina, Sloan, Colton, Brooklyn,
Everleigh, Carson, and Weston.

My deepest thanks to the many people who helped make this book happen,
especially Robert Abrams, David Fabricant, Matt Garczynski, Ada Rodriguez,
Misha Beletsky, Christina Hogrebe, Colleen Mohyde, and as always,
my husband, Mitch Semel.

—Colleen Carroll

Jacket and Cover Front: Audrey Weber. *Marine Turtle*, c. 1955. (see also p. 32)

Editor: Matt Garczynski
Design: Misha Beletsky
Layout: Ada Rodriguez
Production Manager: Louise Kurtz

Second edition
1 3 5 7 9 10 8 6 4 2

Library of Congress Cataloging-in-Publication Data available upon request

For bulk and premium sales and for text adoption procedure, write to Customer Service Manager,
Abbeville Press, 655 Third Avenue, New York, NY 10017, or call 1-800-ARTBOOK.

Visit Abbeville Press online at www.abbeville.com

contents

Animals and Birds

Chauvet-Pont-d'Arc Cave, Ardèche, France

and

Black Rhinoceros

(from the Endangered Species series)

by Andy Warhol

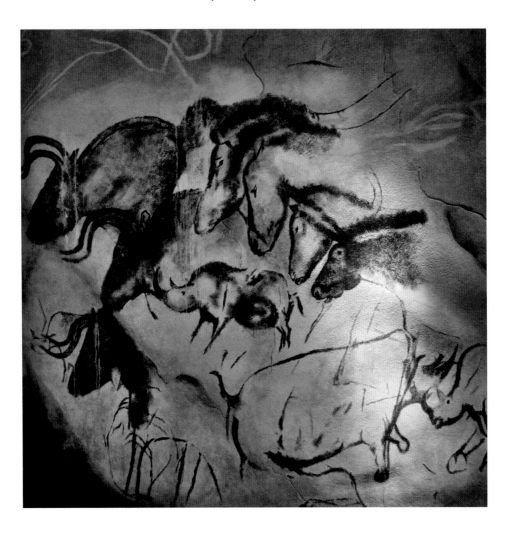

Did you know that the very first paintings are pictures of animals? Thousands of years ago, people made pictures of lions, horses, bison, and many other kinds of animals on cave walls. Some of the animals

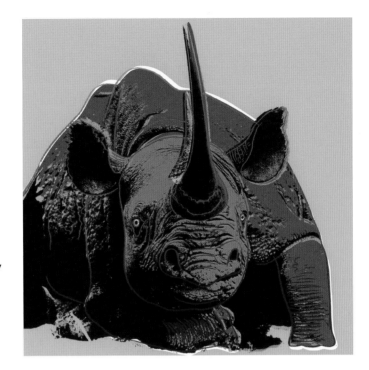

you're about to see will look familiar to you, while some may surprise you. Keep reading to discover many of the ways that artists see animals.

The animals in the cave painting are drawn with strong outlines and shaded in black charcoal. What kinds of animals do you see? Some of the animals have hairy coats, while other animals have smooth hides. How did the artist use the charcoal and the wall's rough texture to make the animals more lifelike? Now look at the black rhinoceros, made 30,000 years later. Like his prehistoric ancestor, the artist who made this picture used lines and color to make the animal come to life. If the rhinos could talk to each other, what might they say?

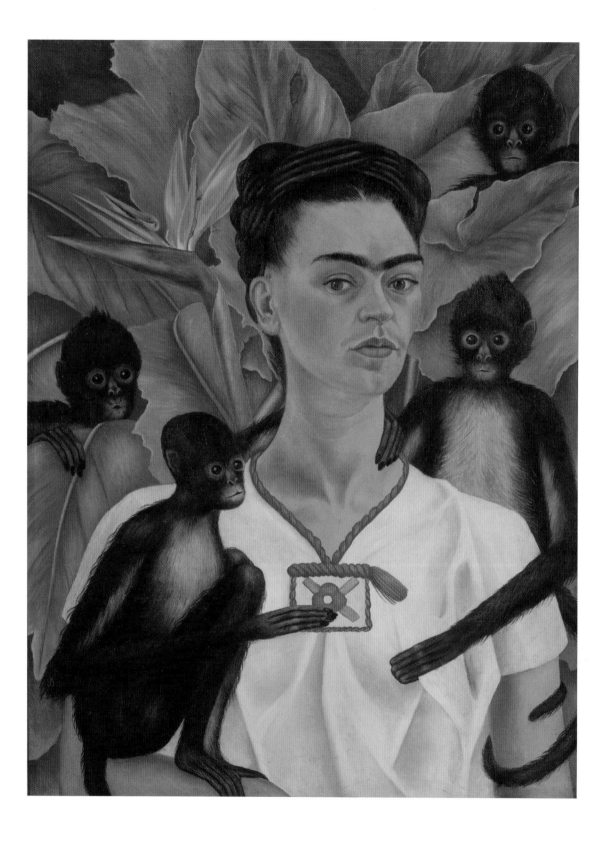

Self-Portrait with Monkeys
by Frida Kahlo

In this self-portrait, the artist poses with her pet spider monkeys. Although she turns her head slightly to the left, her eyes look directly at the viewer (that's *you*). The artist placed her beloved pets in a way that helps your eyes focus on the main subject of the picture: herself! By placing two monkeys on her right side, and two more on her left side, she made it easy to keep looking in the middle of the picture.

Two of the monkeys stick close by the artist, much like small children often do with their mother. How does this pair show their affection for her? The other two monkeys pop their heads up from behind the large leaves of a bird of paradise blossom, as if they are playing a game of hide and seek. If they could speak, what do you think they would say?

7

Young Hare
by Albrecht Dürer

The hare in this painting looks so much like the real thing that it might hop off the page any moment! By using many different brushstrokes, the artist helps you imagine the textures of the animal's body: fluffy coat, velvety ears, rigid whiskers, and sharp pointed claws. Close your eyes and imagine yourself petting this shy animal. What do you feel?

Even though actual rabbits and hares are hopping, twitching, thumping, scratching creatures, this animal lies still, crouching as if frightened or taken by surprise. Look closely at the animal's right eye. What do you see reflected there? Why do you think the artist chose to include this detail?

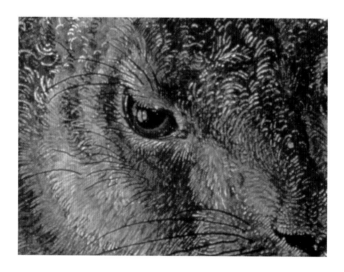

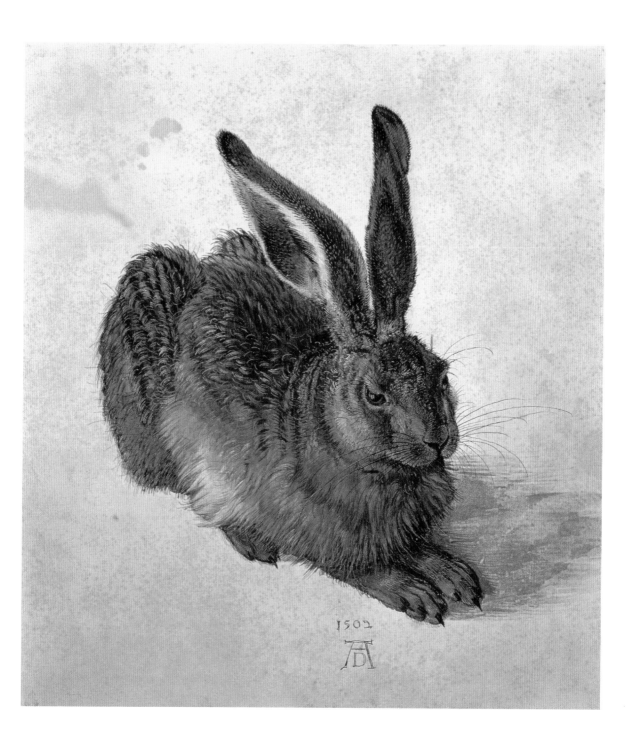

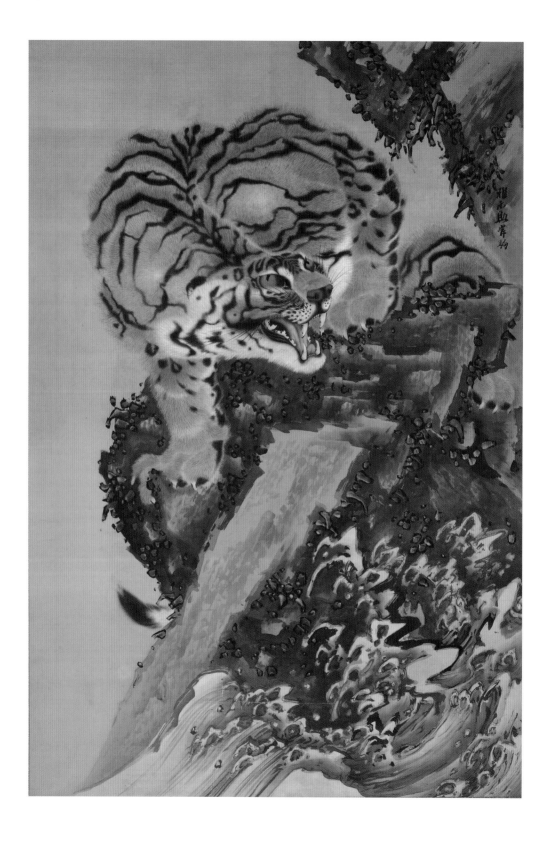

Tiger by a Torrent
by Kishi Ganku

No one would mistake this tiger, with its deep orange coat, black stripes, and bright emerald eyes, for any other animal. The tiger balances its weight on its enormous paws and twists its body toward something on the other side of the stream. With curving lines, the artist captures the grace, power, and strength of this ferocious feline. Trace your finger around the outline of the tiger's body. (Don't forget the tail!) How do these lines help you imagine the tiger's movement?

Like the timid hare you just saw, this animal also looks off into the distance at something you can't see. The tiger glares and snarls, poised for action. What do you think it sees? If you could make this picture come to life, what would happen next?

11

Midnight—Black Wolf
by Robert Bateman

As you enter this moonlit forest, you may sense that you're not alone. Look into the background and follow the light of the moon. There! You have found the majestic black wolf. Using black and dark grays, the artist camouflages the wolf among the stand of trees, allowing its shape to emerge from the scene as if by magic. In what other ways does the artist blend the wolf into the environment?

Although most people know wolves as villains in fairy tales, they are rarely a threat to people. The wolf stares at you, curious, but means you no harm. The soft moonlight casts a blue glow on the snowy forest floor. Where else do you see the moonlight? How has the artist used color to create a feeling of calm?

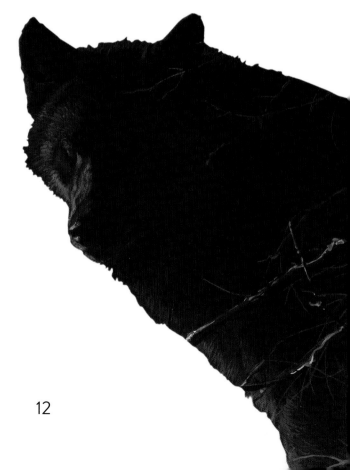

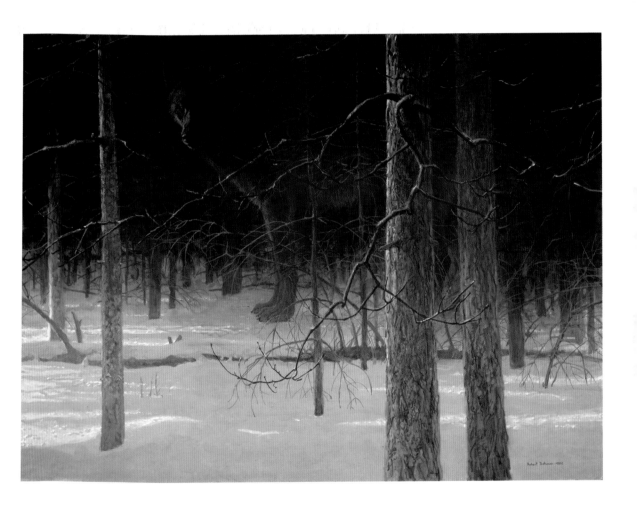

The Goldfish Bowl
by Henri Matisse

You've probably seen these fish before. Well, not these exact fish, but fish like them. They're goldfish, of course! These goldfish swim in a painted world surrounded by bold colors and patterns. Some of the patterns are made of shapes that look like fish. Point to all the fishy shapes you can find. Now look at the patches of orange paint floating at the top of the bowl. What do you think they are?

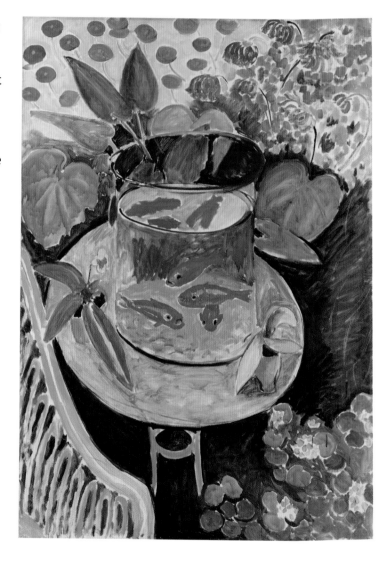

Goldfish Bowl, II

by Roy Lichtenstein

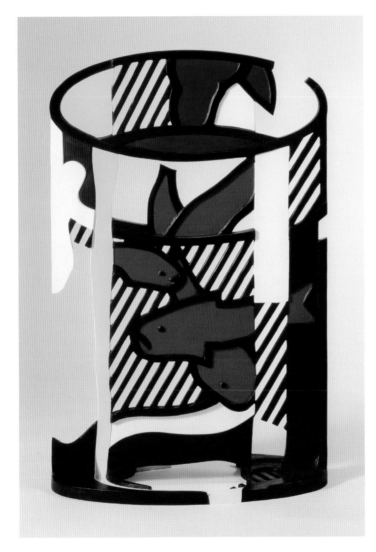

Sometimes artists get ideas by looking at the works of other artists. Here's another bowl of goldfish made by a different artist. It has some things in common with the previous painting, yet there are also differences. First, this artwork is a sculpture made from metal. Second, these fish have heavy black outlines to show the shape of their bodies. What other similarities and differences can you find? Which style do you prefer?

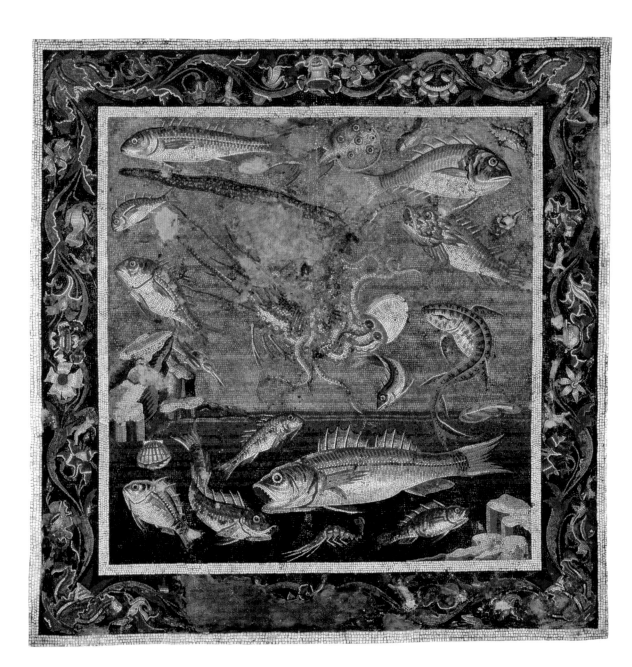

Marine Fauna

from House of the Faun, Pompeii, Italy

This ancient Roman mosaic, made from thousands of pieces of stone and glass, shows an ocean bursting with life. Many types of fish, a clam, a ray, and even an eel have come to watch a mighty battle: octopus versus spiny lobster. Point to the octopus in the center of the picture. Who appears to be winning?

Some of the fish swim beneath the surface, while others leap out of the water. Some appear frozen, while others twist and reach into the air. Which ones feel more alive? Starting with the big fish in the water, trace your finger around the four sides of the scene. What do you see along the way? Why do you think the artist chose to place these creatures on each side of the picture?

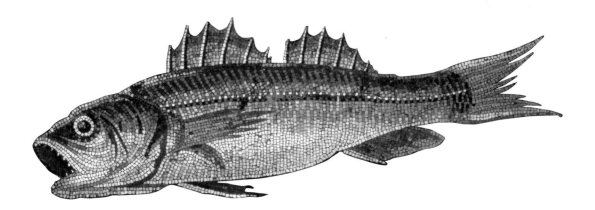

Fish
by Alexander Calder

Artists often use materials in surprising ways. The sculpture is made with lots of odds and ends, such as broken glass and pottery, buttons, beads, and stones—the kinds of things that often get thrown away.

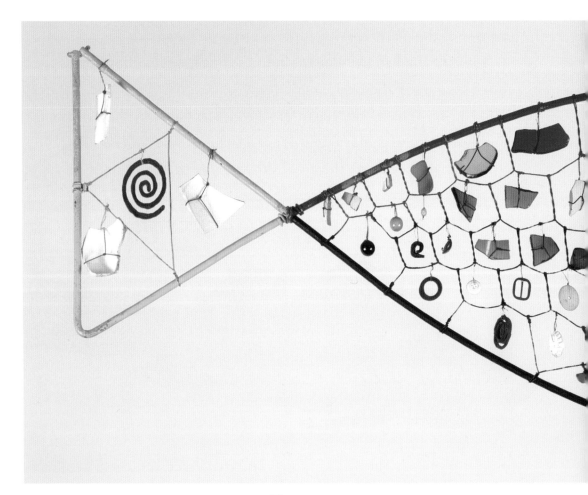

What other unusual materials can you find? By assembling this collection of junk, each piece hanging in its own space, the artist helps you imagine the scales of a fish. Some of the items are smooth and slippery, some are rough and sharp. Why do you think the artist chose the round, green glass object for the fish's eye?

This type of sculpture, called a *mobile*, hangs from the ceiling and is moved by currents of air—almost as if it were swimming. Imagine this hungry fish moving through the water with its mouth agape. How many tiny fish do you think it could swallow at once?

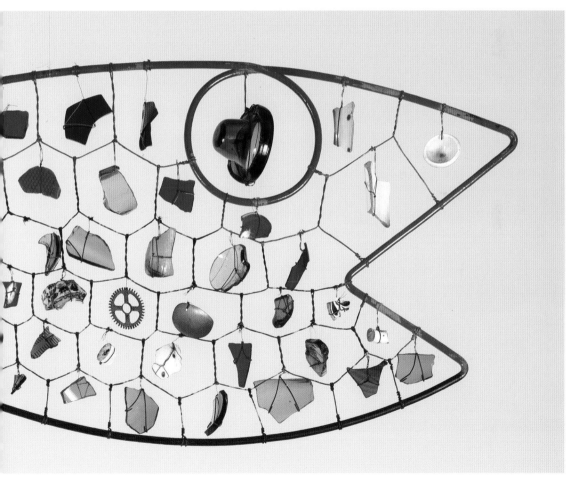

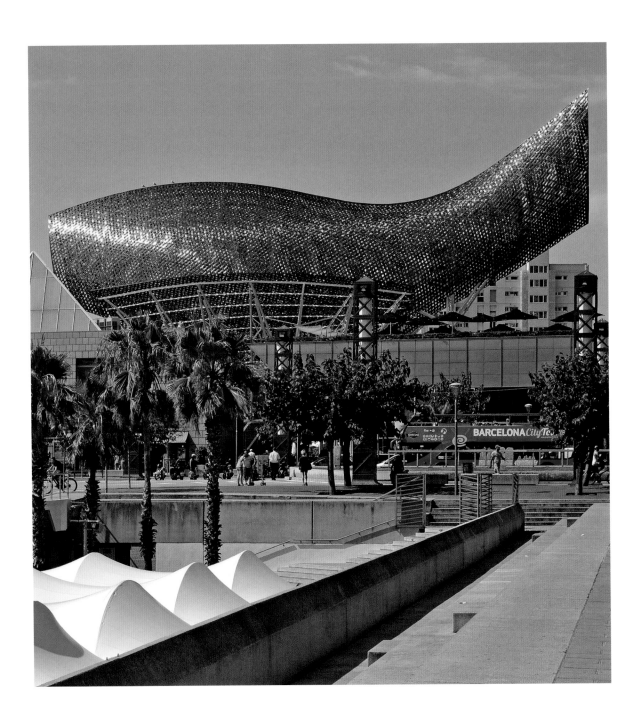

El Peix (The Golden Fish)

by Frank Gehry

Now there's a fish out of water! Like a lifeguard, this sculpture watches over the swimmers and sunbathers below. Unlike the realistic mosaic fish you saw a few pages ago, this sculpture is made from simple lines that *suggest* the shape of a fish. Trace your finger around it to experience how the artist imagined and created its shape. How is this colossal fish like (and unlike) the goldfish you have already seen?

Made from woven strips of tinted stainless steel, the fish glows yellow in the midday sun and turns a warm bronze in the orange light of the afternoon. As long as the sun is out, its rays dance off the metal, just as sunlight reflects off the scales of real fish. If it gets too hot, this giant just might flick its terrific tail and flop into the sea for a dip. Imagine the splash it would make!

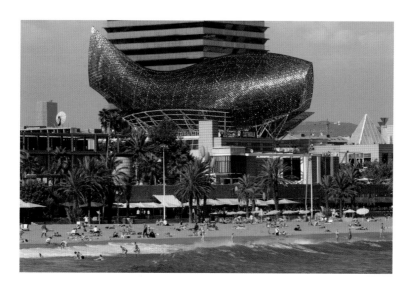

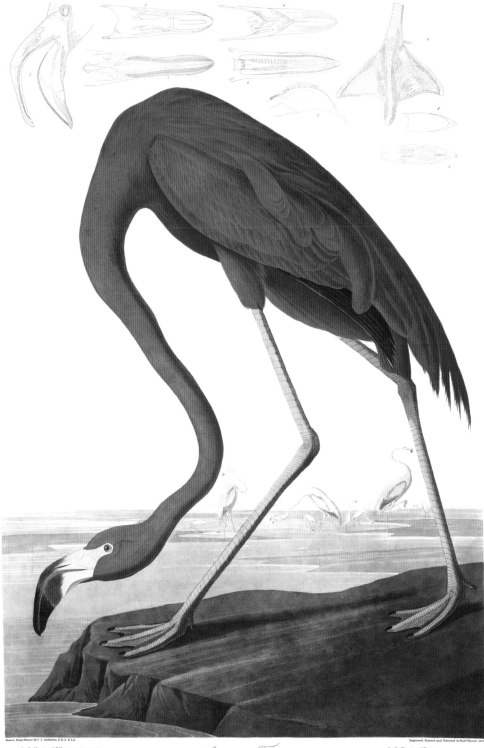

Drawn from Nature by J. J. Audubon, F.R.S. F.L.S.

Engraved, Printed and Coloured by Rob.t Havell. 1838.

1.— Profile view of Bill at its greatest extension.
2.— Superior front view of upper Mandible.
3.— Interior front view of upper Mandible.
4.— Inferior front view of lower Mandible.
5.— Interior front view of lower Mandible with the Tongue in.

6.— Profile view of Tongue.
7.— Superior front view of Tongue.
8.— Inferior front view of Tongue.
9.— Perpendicular front view of the foot fully expanded.

American Flamingo
PHŒNICOPTERUS RUBER, Linn.
Old Male.

American Flamingo
by John James Audubon

This flamingo is really "in the pink." The artist who made the picture spent most of his life watching all kinds of birds and drawing them in their natural environments. Can you tell where home is for these leggy birds? The big flamingo in the foreground bends its spindly left leg and lowers its head toward the water. Trace your finger along its curving neck. What do you think the bird is doing in this awkward position?

If you look through its legs into the background, you'll find more flamingos in funny positions. By making the other birds smaller and the colors lighter, the artist creates the feeling of distance. Be a flamingo and stand on one leg. How long can you hold this position?

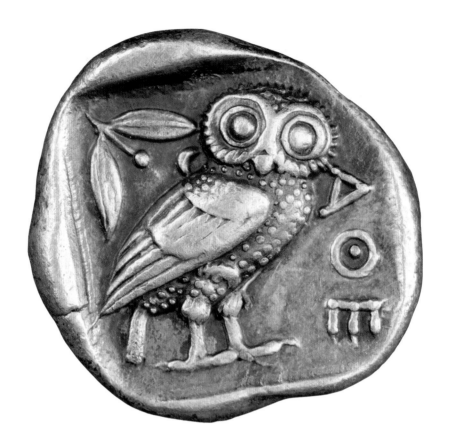

Owl of Athena

on Athenian coin, Greece

This adorable bird hatched nearly two thousand years ago—not as a picture to hang on a wall, but as a coin. Though it is no taller than an acorn, its charm, style, and charisma make up for its diminutive size. How did the artist use detail to give this bird its plucky personality?

Blue Owl
by Tamás Galambos

Here's a much more modern owl. It would be nearly impossible not to notice this colorful creature, staring right at you with unblinking yellow eyes. Like the *Young Hare*, this picture was made using watercolor paint. The artist applied thousands of tiny brushstrokes to create the intricate pattern of the bird's feathers. How many different patterns can you find? Unlike the *Young Hare*, this bird is unusually colorful! Why do you think the artist chose to paint an owl with blue feathers?

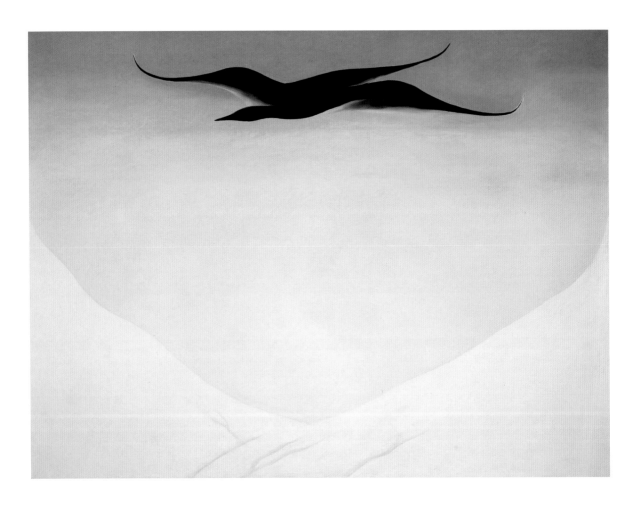

A Black Bird with Snow-Covered Red Hills
by Georgia O'Keeffe

In this picture, a solitary black bird glides over a snow-covered mountain range. With gently curving lines, the bird makes up in beauty what it lacks in detail. Unlike some of the birds you've already seen, this one is made up of just a few simple shapes, calling to mind its wings, body, head, and tail. Without the details of the bird, you are left with only a form in flight. Do you think this artist wanted you to think about what an actual black bird looks

like, or to help you imagine what it would be like to soar like one? If you could hitch a ride on the back of this sleek bird, what would it feel like? Move your arms through the air as if *you* were gliding over these snowy hills.

The Turning World (I)
by Ana Maria Pacheco

For thousands of years, the dove has been a symbol of peace. In this relief sculpture, carved from a single piece of wood, a dove perches on a golden sphere that floats in a starry blue sky. The bird's feathers are carved in great detail, shimmering in gold and white. Imagine stroking the dove's body. What do the feathers feel like to you? How does the sky filled with golden, twinkling stars create a feeling of peace and calm?

Look carefully at the bird's wings. They are neither flat against its body nor fully open. Placing the wings in this position helps you imagine their movement. Do you think this dove has just landed on the sphere, or is it about to fly away?

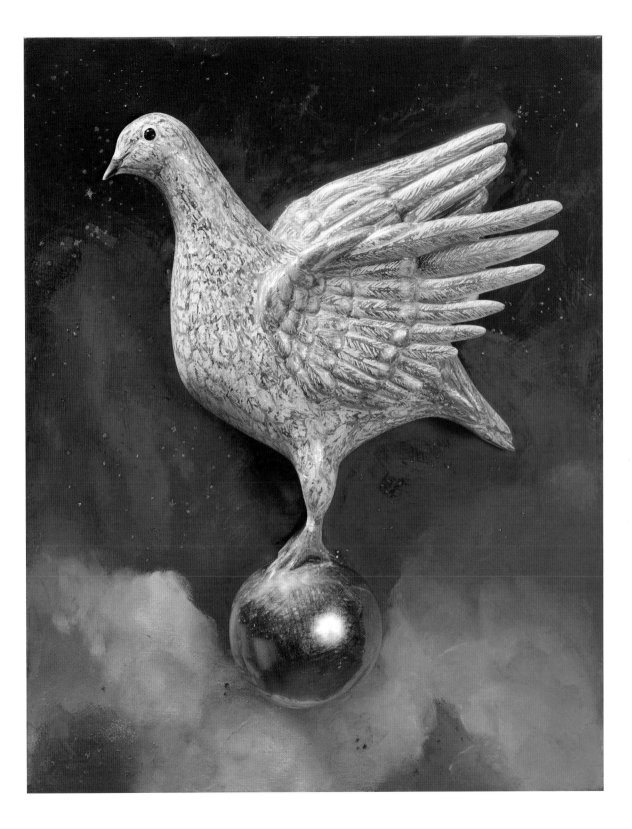

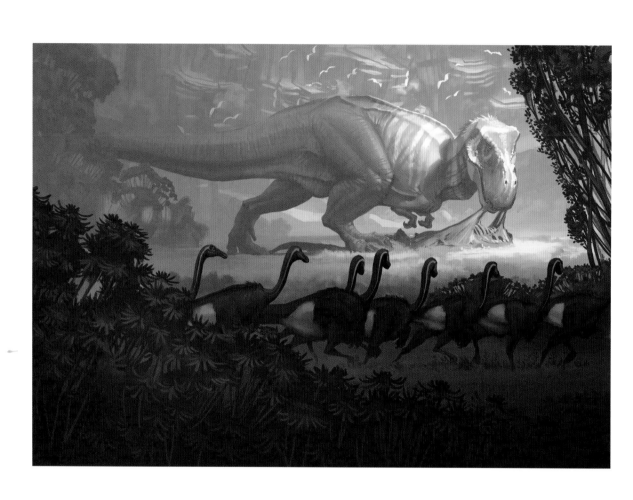

Tyrannosaurus
by Simon Stålenhag

Although frozen in a moment, this picture pulses with action. Set against a background landscape of craggy hills and a distant river, the giant carnivore is nearly done with its meal. In the foreground, a flock of smaller, birdlike dinos takes a quick glimpse as they scurry away, eager to avoid a similar fate. Where would you take cover if you were in this clearing?

If you could go back in time to when dinosaurs roamed the earth, what would it look like? Because bones are some of the only things that survived of these extinct creatures, the artist used his imagination to show what the animal may have looked like, giving it orange skin and white stripes. Why do you think he chose such a vivid color and bold pattern? What other details did the artist include to make his dinosaur king so frighteningly real?

Marine Turtle

by Audrey Weber

Unlike the dramatic *Tyrannosaurus*, this picture is one of calm and serenity. Cool colors, such as greens and blues, often create a feeling of peacefulness. How do the colors help create the mood of the picture? The underwater blues and greens change to lighter shades of blue above the surface. Trace your finger over the graceful lines of green paint flowing over the turtle's patterned shell to experience the flow of the water.

The turtle swims slowly to the surface as it makes its way toward the beach. It may be going there to lay its eggs and then return back to a solitary life in the sea. Use your finger to draw a line from the turtle's head to the land in the distance. How much farther do you think the turtle will have to swim until it crawls safely onto the sand?

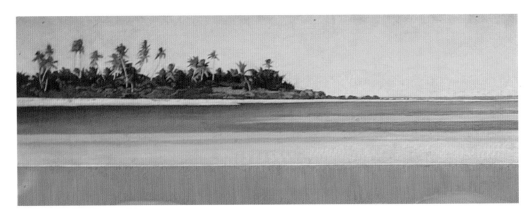

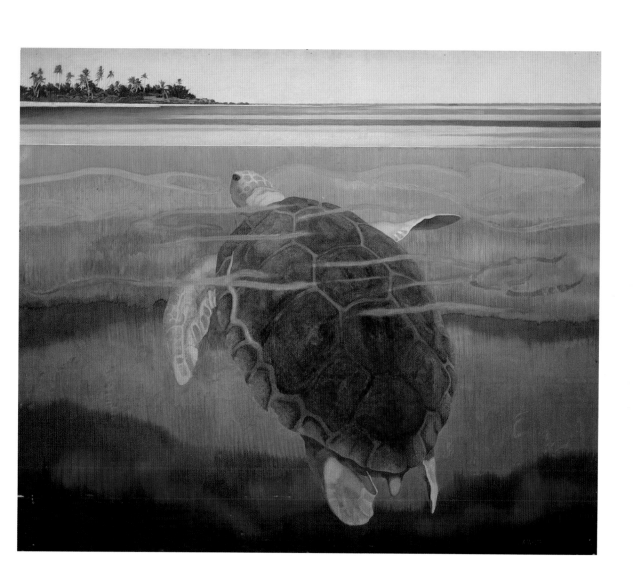

Street Art in Bogotá, Colombia
by Crisp

If you ever meet a frog this big, don't stop and say *ribbit* . . . just get out of the way! The artist used the side of a building to paint this neon-green amphibian. With such a large space to paint on, the artist was able to make his frog many times larger than it exists

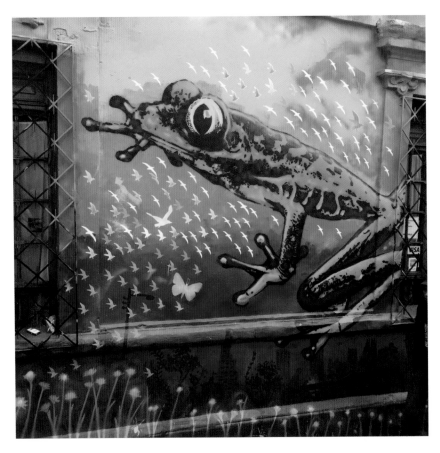

in nature. (Actual yellow-eyed tree frogs are only a few inches long.) How does the scale of this funky frog make the picture exciting to look at?

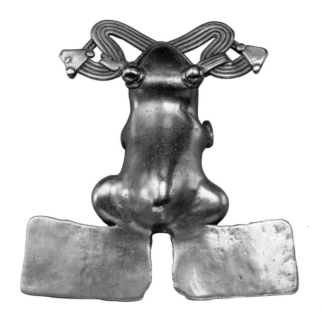

Frog Pendant
Chiriquí Peoples

Unlike its oversized cousin, this golden frog is no longer than a stick of chewing gum. Originally made to hang from a necklace, it looks very much like a frog in some ways, and not at all like a frog in other ways. For example, the head and body are very "froggy," yet the hind legs and feet look like paddles! The frog's *bifurcated*, or forked, tongue darts from its mouth. How do these wavy lines mimic the movement of a frog hunting its prey? If you could be one of these leapers for a day, which one would you pick?

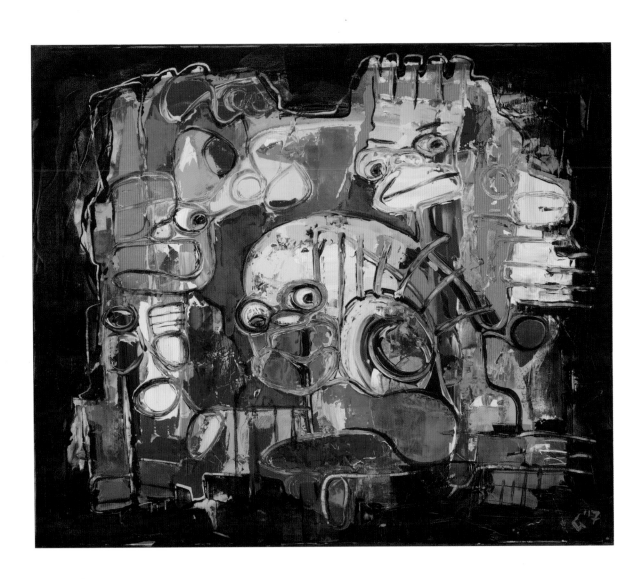

At the Zoo — Reptile

by Georges De Groot

Step into the reptile house, where all around you live the relatives of the mighty dinosaurs: lizards, snakes, turtles, alligators, crocodiles, and more. Some of the reptiles are easy to spot, like the yellow creature in the center of the picture. To find them all, let your eyes travel around the space. Point to all the reptiles you can spot. What clues does the artist give to help you find the creatures who live here? Wriggling with vivid colors, winding lines, and a variety of shapes, this reptile house vibrates with movement. Trace your finger around the lines to experience the upbeat energy of this reptilian house party.

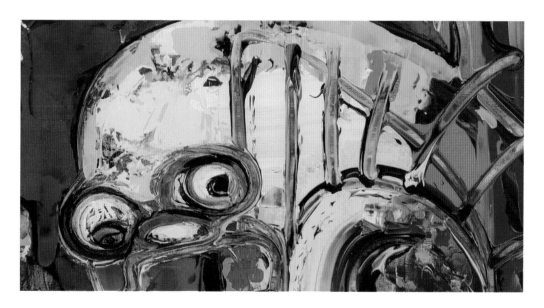

Surinam Caiman Protecting Her Hatchings from a Coral Snake

by Marie Sybilla Merian

A word of advice to all snakes: don't mess around with this mama caiman! Engaged in a battle of life and death, a mother caiman (a close relative to crocodiles) fights to keep a coral snake from devouring one of her hatchlings. Another one of her young has just begun to emerge from the safety of its egg. Besides this

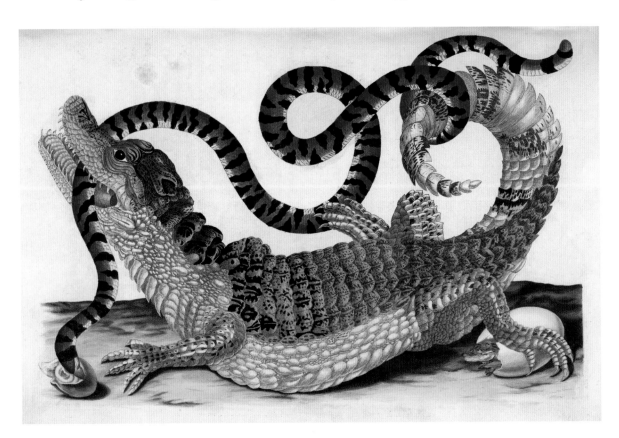

frightened baby, everything in the picture is moving. How does the artist show the action of the animals as they fight?

This artist spent many years of her life observing and drawing plants and animals. She was very careful to make her pictures as realistic as possible, such as the bony ridge atop the caiman's head, and the pattern of the snake's skin. What other details do you see that show you the way these animals appear in nature?

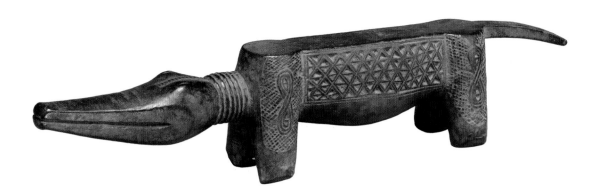

Friction Oracle
Kuba Peoples

This carved, wooden crocodile depicts a similar creature quite differently. The shape of its head and sly smile are unmistakably crocodilian, but look carefully at its body. How is this croc's body unlike the real reptile?

Now that you've discovered how some artists see animals, use your own unique vision to create a picture of your favorite animal.

Over the years I've shown children many examples of great art, both as a teacher and as a visiting author to schools across the United States. I am always amazed at how enthusiastically children respond to art, and how their imaginations are fired by the colors, lines, and shapes, the subject matter, and the moods and feelings of the artworks. When I ask them challenging questions about art, they engage with it even more actively, and their thoughts lead them in all sorts of interesting directions. In today's world, providing children with healthy ways to build visual literacy skills is as important as ever. Looking closely at art and talking about it is one excellent way of doing just that.

How Artists See teaches children about the world by looking at art, and about art by looking at the world. Each volume is devoted to a universal subject in art, so that children can see how different artists have approached the same theme and begin to understand the importance of individual style. The questions in this book are open-ended, with no right or wrong answers—they are meant to encourage children to look critically and ask thought-provoking questions of their own.

How Artists See is not an art history primer, but for children who want to learn more about the artists whose works appear in the book, I've provided short biographies at the end, along with books and websites with more in-depth biographical and historical information.

After reading *How Artists See Animals*, continue the learning by visiting a local zoo or wildlife sanctuary, sketchbooks in hand, to observe and draw the animals. Encourage children to write stories featuring the animals in their lives and to visit their public library to find additional books starring their favorite animals.

I hope that you and your children or students will enjoy reading and rereading this book and, by looking at the many styles of art, discover how artists share with us their unique ways of seeing the world.

—Colleen Carroll

Cave painters
(c. 30,000–10,000 BC)

Perhaps the greatest mystery in all of art lies in the prehistoric paintings found on cave walls in what are today the countries of France and Spain. Often these caves are rediscovered by accident, in difficult-to-reach places. The Chauvet Cave, featured in this book, had been closed off by a landslide until three cave explorers began clearing away the rubble in 1994. Little is known about the artists who made these paintings of bulls, horses, deer, and other animals with nothing more than burnt sticks (to make charcoal) and clay. Some experts think the paintings served a spiritual purpose; others think they were made to bring good luck and power to hunters. Whatever the reasons, these paintings tell us that people have been making art and expressing themselves in creative ways for over 30,000 years.

Bradshaw Foundation. "The Cave Art Paintings of the Chauvet Cave." http://www.bradshawfoundation.com/chauvet/

Dubowski, Mark, and Bryn Barnard. *Discovery in the Cave: A History Reader.* Step into Reading. New York: Random House, 2010.

Andy Warhol (1928–1987)

"If you want to know everything about me, just look at the surface of my paintings, it's all there, there's nothing more."

The American Pop Art painter who said these words was born Andrew Warhola, in Pennsylvania to immigrant parents. He is known as a "Pop" artist because of his paintings of popular things that people can recognize from everyday life. As a young man, he worked as a commercial illustrator. In the early 1960s he began to create works of art with subjects borrowed from the world of advertising. Warhol (pronounced *WAR-hall*) depicted common products such as soap boxes and soup cans in paintings and works on paper. His work seemed outrageous at the time, yet it propelled Warhol to fame and fortune. In addition to painting and printmaking, Warhol made films and founded a magazine called *Interview*. Never one to believe that fame can last forever, he once said, "Everyone will be famous for fifteen minutes," but his groundbreaking art made Warhol one of the most famous and unforgettable artists of the twentieth century.

Anderson, Kirsten, and Gregory Copeland. *Who Was Andy Warhol?* New York: Grosset & Dunlap, 2014.

Tate. "Who is Andy Warhol?" Tate Kids. https://www.tate.org.uk/kids/explore/who-is/who-andy-warhol/

Frida Kahlo (1907–1954)

As a little girl, Frida Kahlo (pronounced *KAH-low*) contracted the disease polio, which left her with a limp for the rest of her life. In her late teens, she was in a horrible bus accident that nearly killed

her. Hospitalized to recover from her serious injuries, she began to paint. She never completely recovered, but she never stopped painting. She once said, "I am not sick. I am broken. But I am happy as long as I can paint." Kahlo is most known for her self-portraits, such as the one featured in this book. In these works she is often in traditional Mexican costumes or with objects that celebrate her Mexican heritage. Many of her paintings depict the physical and emotional pain that she felt throughout her life, as a result of the accident and her difficult marriage to the famed Mexican artist Diego Rivera. Today, Kahlo's works are prized throughout the world, and they symbolize and celebrate the triumph of the creative spirit over life's adversities.

Brown, Monica, and John Parra. *Frida Kahlo and Her Animalitos*. New York: NorthSouth Books, 2017.

Albrecht Dürer (1471–1528)

As a boy, the German painter, watercolorist, and printmaker Albrecht Dürer (pronounced *DER-er*) was an apprentice in the workshop of a book illustrator. There, he learned to draw and to make prints, such as woodcuts, and engravings. Although Dürer was a talented painter, it was his prints that made him famous because they were sold all over Europe. He was a master at showing detail in his work, such as the subtle textures seen in *The Hare*. He also wrote books on his scientific and artistic ideas. Albrecht Dürer is considered one of history's most gifted artists.

Pioch, Nicolas. "Dürer, Albrecht." WebMuseum. June 19, 2006. https://www.ibiblio.org/wm/paint/auth/durer/

Kishi Ganku (1750–1838)

Kishi Ganku (pronounced *GON-coo*) was a mostly self-taught Japanese painter who lived during the middle of the Edo Period, a time of great artistic achievement in Japan. As a young man he traveled all over the country and eventually made his home in Kyoto. Like many Japanese artists of the day, Ganku founded his own school of painting, called the Kishi school. He is best known for his realistic and energetic paintings of animals in their natural habitats.

Ministry of Foreign Affairs of Japan. "Virtual Culture: Ukiyo-e." Kids Web Japan. https://web-japan.org/kidsweb/virtual/ukiyoe/index.html

Robert Bateman (born 1930)

As a young artist, the Canadian painter Robert Bateman tried out many styles before finally settling upon the realism for which he is known. His love of nature has led him to speak up on a number of environmental issues over the years. He once said, "I can't conceive of anything being more varied, rich and handsome than planet earth . . . I want to soak it up, to understand it . . . then put it together and express it in my paintings." In 2013, he helped establish the Robert Bateman Centre in Vancouver, Canada, where visitors can learn more about the wonders of the natural world and view many of the artist's paintings.

Bateman Foundation. "A Living Legend Strides The World of Art And Nature." BatemanCentre.org. https://batemancentre.org/robert-bateman/

Henri Matisse (1869–1954)

During his long lifetime, Henri Matisse (pronounced *mah-TIECE*) worked in many different styles. Early in his career he was the leader of a group of painters called the Fauves, which in French means "wild beasts." The Fauves believed that color was the most important element in painting and they used it in bold ways. In one of Matisse's most well-known portraits, he painted his wife's face bright green! His favorite subjects included dancers, still lifes, and interiors of colorful rooms. Late in his life, when he could no longer paint, Matisse made collages out of brightly-colored paper, which he called "cut-outs." Along with Pablo Picasso, Matisse is known as "the father of modern art," because his ideas took art in new directions.

MacLachlan, Patricia, and Hadley Hooper. *The Iridescence of Birds: A Book About Henri Matisse.* New York: Roaring Brook Press, 2014.

Tate. "Who is Henri Matisse?" Tate Kids. https://www.tate.org.uk/kids/explore/who-is/who-henri-matisse/

Roy Lichtenstein (1923–1997)

Like his contemporary Andy Warhol, Roy Lichtenstein was one of the pioneering figures of the Pop Art movement. Lichtenstein (pronounced *LICK-ten-stine*) is most famous for his comic book–style paintings—pictures that show the bright colors, black outlines, and Benday dots of real newspaper comic strips. He is also known for using this unique style to recreate the works of other artists, as in the sculpture in this book.

Berman, Avis. "Biography." Lichtenstein Foundation. https://lichtenstein foundation.org/biography/

Rubin, Susan. *Roy's House.* San Francisco: Chronicle Books, 2016.

Ancient Roman mosaics (c. 1st century, AD)

The mosaic featured in this book was uncovered among the ruins of the ancient city of Pompeii, which was buried in ash in 79 AD after the eruption of Mount Vesuvius sent 20 feet of ash and dust into the air. Most mosaics were created as decorative floors, making them both beautiful and practical at the same time. In addition to animals, such as in *Marine Fauna*, popular subjects included hunting and battle scenes, mythology, and scenes from everyday life. Artists placed tesserae, small cubes of stone, ceramic, or glass, into mortar to assemble the image. Because of their durability, many ancient mosaics have survived, providing a fascinating glimpse into the lives of the ancient Romans.

Pappalardo, Umberto, and Rosario Ciardiello. *Greek and Roman Mosaics.* New York: Abbeville Press, 2019.

Stephan, Annelisa. "A Brief Introduction to Roman Mosaics." The Iris: Behind the Scenes at the Getty. April 4, 2016. https://blogs.getty.edu/iris/a-brief-introduction-to-roman-mosaics/

Alexander Calder (1898–1976)

The son and grandson of sculptors, this American artist learned from an early age how to make things. As a young man living in Paris, France, he made his now famous wire *Circus*, complete with movable clowns, animals, and acrobats. He is best known for this mobiles—sculptures made of flat, brightly colored metal shapes that look like objects from nature, such as fish, leaves, or animals. These sculptures are hung from the ceiling with wire and move with the changing air currents. Calder also made large metal sculptures known as stabiles (like the word "stable"). These stabiles, which don't move, are most often found in wide, open spaces, such as city squares and square gardens.

Calder Foundation. "Biography." Calder. org. http://www.calder.org/life/biography

Geis, Patricia. *Meet the Artist: Alexander Calder*. New York: Princeton Architectural Press, 2014.

Frank Gehry (born 1929)

Canadian-born architect, Frank Gehry, once said, "Architecture is art." After earning degrees in both architecture and urban planning, Gehry founded a small architectural firm in Los Angeles, which became the start of a long and successful career. His works are known for their sculptural qualities, movement, and unusual shapes. Some of his most famous creations include the Walt Disney Concert Hall in Los Angeles, and the Guggenheim Museum in Bilbao, Spain. In 1989, Gehry won the prestigious Pritzker Prize for architectural excellence. His buildings can be seen in cities all over the world.

Academy of Achievement. "Frank O. Gehry." Achievement.org. https://www.achievement.org/achiever/frank-gehry/

John James Audubon (1785–1851)

Born in Haiti and raised in France, Audubon (pronounced *AW-due-bon*) moved to America at the age of eighteen, where he lived and worked for the rest of his life. Audubon was fascinated by birds, and decided to devote his life to studying and painting them as they appear in their natural environments. He traveled all over the country, searching for as many species as he could find. Audubon shot and killed hundreds of birds in order to study them for his paintings, but he came to believe that this practice was wrong and that all people must do their part to protect wildlife. Audubon collected his bird portraits in a book called *Audubon's Birds of America*.

Davies, Jacqueline, and Melissa Sweet. *The Boy Who Drew Birds: A Story of John James Audubon*. Boston: Houghton Mifflin, 2004.

National Audubon Society. "The American Woodsman: Our Namesake and Inspiration." Audubon.org. https://www.audubon.org/content/john-james-audubon

Tamás Galambos (born 1939)

Tamás Galambos is a highly respected contemporary Hungarian artist. Born in Budapest, Galambos has often been

called an "outsider artist," due to the unusual qualities in his works that defy the mainstream. His nature paintings, mythological scenes, and animal imagery incorporate elements of fantasy in a style known as magical realism. Galambos' work has been used on book covers and has been widely reproduced as posters both in Hungary and around the world.

Ancient Greek coin (480–420 BC)

The ancient Greeks began using coins in the early sixth century BC as an alternative to bartering (trading) for goods and services. Over time, each Greek city-state had its own coinage. These coins were usually made from silver, or a mixture of silver and lesser quality metals. Typically, one side of the coin (the obverse) had a stamped head of the city's patron god or goddess. On the other side (the reverse) appeared the patron animal of that god or goddess. The *Little Owl* in this book is the patron animal of the goddess Athena, who lent her name to the city-state of Athens.

Cartwright, Mark. "Ancient Greek Coinage." Ancient History Encyclopedia. July 15, 2016. https://www.ancient.eu/Greek_Coinage/

Georgia O'Keeffe (1887–1986)

When the American painter Georgia O'Keeffe was a child of twelve, she told a friend that someday she would become an artist. She went to art school and later became a teacher. At twenty-five years old, she sent some of her watercolor paintings to a friend in New York City, who showed them to the famous photographer and gallery owner Alfred Stieglitz. So impressed by the paintings, Stieglitz hung them in his gallery without even asking for O'Keeffe's permission! That was the start of her long and amazing career as an artist. (Stieglitz would later become her husband.) Her paintings show ordinary things in unusual ways, such as a single flower that fills up the entire canvas, sun-bleached animal bones, seashells, and desert hillsides. After many years of living in New York City, O'Keeffe moved to New Mexico, where she lived and painted until her death at the age of ninety-eight. Her work is some of the most beloved and recognizable art in the world.

Georgia O'Keeffe Museum. "About Georgia O'Keeffe." OKeefeMuseum.org. https://www.okeeffemuseum.org/about-georgia-okeeffe/

Muun, Marina. *Meet Georgia O'Keeffe*. London: Tate Publishing, 2017.

Ana Maria Pacheco (born 1943)

Brazilian sculptor, painter, and printmaker Ana Maria Pacheco (pronounced *pa-SZHAY-co*) studied art in her hometown of Goias, Brazil, earning degrees in sculpture and music. She continued to study art in Brazil before moving to London to continue her education and teach at the university level. Although she works in multiple media, she is most known for her sculptures: multifigure groups as well as reliefs like the one featured in this book. Most of her sculptures are painted, and she often adds unusual objects, such as stones (for eyes), nails, and sometimes even human teeth! Pacheco's artworks appear in many

museums and private collections around the world. She lives and works in London.

Bush, Robert. "The Turning World." Pratt Contemporary. http://www.prattcontemporaryart.co.uk/work/the-turning-world/

Simon Stålenhag (born 1984)

Growing up outside of Stockholm, Sweden, Simon Stålenhag (pronounced *STOHL-en-HAHG*) liked to watch science fiction movies on television. He was also interested in art, especially Swedish landscape painting. After studying game design, Stålenhag became a video-game designer. As an artist, he makes digital images with a computer and a digital drawing board, but many start with a photograph. The artist has described his subject matter as "cultural Swedish landscapes from the 80s and 90s, populated by robots and dinosaurs." In 2015, his dinosaur paintings were part of the Fossils and Evolution exhibition at the Swedish Museum of Natural History.

"Paleoart." Simon Stålenhag Gallery. http://www.simonstalenhag.se/paleo.html

Audrey Weber (1898–1981)

British oil painter, graphic artist, and illustrator Audrey Weber studied art at the Royal Academy Schools, graduating in 1922. She exhibited at the Royal Academy and at the Society of Women Painters. Weber was commissioned as a freelance artist for the Natural History Museum in London, and produced many paintings for its publications, including the one seen in this book. Weber also worked for the Southern Region Railways in England, where she designed advertising posters.

Crisp

This Australian-born artist now living and working in Bogotá, Columbia, was the child of artists. He studied and worked in Sydney, Australia before traveling the world, where he would often photograph street art. Ultimately, he began to make his own street art. Crisp's "canvases" are the walls and sides of buildings. In an interview, Crisp said, "Sometimes I like to send a message or try to make people think about an issue I feel strongly about . . . Other times I enjoy making blank spaces or congested parts of the city more beautiful by adding scenes that depict nature and the wild." Crisp's street art can be seen in many cities around the world, including London, New York, and Miami.

Crisp Street Art. http://www.crispstreetart.com

Chiriquí peoples (11th–16th century)

The indigenous peoples of what are now Mexico and the countries comprising Central America were masterful in the art of metalwork, as can be seen in the frog pendant featured in this book. Objects such as crowns, necklaces, earrings, and chest plates were used to decorate a person's body. Gold, a precious metal, was worn by wealthy individuals or ones of high rank. These pieces were of the highest craftsmanship and often had symbolic meanings to the wearer.

Pillsbury, Joanne, Timothy Potts, and Kim N. Richter, eds. *Golden Kingdoms: Luxury Arts in the Ancient Americas.* Los Angeles: Getty Trust Publications, 2017.

Georges de Groot (born 1974)

Inspired by his life experiences and childhood stories of monsters and fairies, this Dutch painter is known for work that combines playful characters, such as the reptiles seen in this book, with abstract shapes, pulsating lines, and vivid colors. De Groot lives and works in the Netherlands.

Georges de Groot. http://www.georgesdegroot.nl

Maria Sybilla Merian (1647–1717)

As a child, Maria Sybilla Merian was fascinated by insects. She especially loved to watch silkworms, carefully observing and drawing them as they moved through their life cycle. Merian was encouraged at a young age by both her father and stepfather to draw, and draw she did! She married and had two daughters and continued to observe and illustrate the caterpillars that she raised in her home, detailing each phase from pupa to butterfly. She also made drawings of plants; her first published book was called *Book of Flowers*, and in 1679 she published *The Wondrous Transformation of Caterpillars.* As her marriage was ending, Merian moved with her daughters to Amsterdam, where she continued to work. In 1699 she traveled with her younger daughter to Surinam, a British colony in South America. For two years she studied the area's plant and animal life, and illustrated what she saw with great detail and accuracy, resulting in the book *Metamorphosis of the Insects of Surinam.* Today, Merian is considered an artist scientist who paved the way for modern botany and zoology.

"Maria Sibylla Merian." History of Scientific Women. https://www.scientificwomen.net/women/merian-anna_maria_sibylla-67

Sidman, Joyce. *The Girl Who Drew Butterflies: How Maria Merian's Art Changed Science.* Boston: Houghton Mifflin Harcourt, 2018.

Kuba peoples (16th century–present)

The Kuba Kingdom, located in what is now the Democratic Republic of Congo, was formed in the sixteenth century. Composed of many ethnic groups, all of which speak the Bantu language, the Kuba people produce sophisticated works of art, such as the crocodile oracle featured in this book. An example of the Kuba's wood-carving techniques, the oracle is an object that was probably used in daily religious ceremonies. The Kuba are also highly respected cloth makers. Kuba textiles are woven, sometimes embroidered, and feature complex geometric designs.

University of Iowa Stanley Museum of Art. "Kuba." Art & Life in Africa. https://africa.uima.uiowa.edu/peoples/show/kuba

Credits

Animals and Birds, c. 30,000 BC. Charcoal on cave wall, Chauvet-Pont-d'Arc Cave, Ardeche, France. Photo © Bridgeman Images.

Andy Warhol (1928–1987). *Black Rhinoceros,* **1983.** Screenprint on Lenox Museum Board, 38 × 38 in. (96.5 x 96.5 cm). © Ronald Feldman Gallery, New York/Andy Warhol Foundation, New York/Artists Rights Society, New York.

Frida Kahlo (1907–1954). *Self-Portrait with Monkeys,* **1943.** Oil on canvas, 32 × 24⅞ in. (81.5 × 63 cm), Jacques and Natasha Gelman Collection, Mexico City, Mexico. © Artists Rights Society, New York. Art Resource, New York.

Kishi Ganku (1758–1838). *Tiger by a Torrent,* **1795.** Hanging scroll, ink and color on silk, 66½ × 45 in. (169 x 114.3 cm), The British Museum, London.

Albrecht Dürer (1471–1528). *Young Hare,* **1502.** Watercolor on paper, 10 × 9 in. (25.1 × 22.6 cm), Graphische Sammlung Albertina, Vienna, Austria. Bridgeman Images.

Robert Bateman (born 1930). *Midnight—Black Wolf,* **1988.** Acrylic on Masonite, 36 × 48 in. © Robert Bateman.

Henri Matisse (1869–1954). *The Goldfish Bowl,* **1912.** Oil on canvas, 57½ × 38⅛ in. (146 × 97 cm.), Pushkin Museum of Fine Arts, Moscow. © Succession H. Matisse/Artists Rights Society, New York.

Roy Lichtenstein (1923–1997). *Goldfish Bowl, II,* **1978.** Painted and patinated bronze, 39 × 25¼ × 11¼ in. (99.1 x 64.1 x 28.6 cm). © Estate of Roy Lichtenstein.

Alexander Calder (1898–1976). *Fish,* **1945.** Rod, wire, plastic, wood, glass, ceramic fragments, and paint, 16¼ × 48½ × 4½ in. (41.3 × 122.2 × 11.4 cm), Hirshhorn Museum and Sculpture Garden, Smithsonian Institution, Washington, D.C.; Gift of Joseph H. Hirshhorn, 1966. © 2019 Calder Foundation, New York/Artists Rights Society (ARS), New York.

***Marine fauna mosaic from the house of the fauna,* 199–80 BC.** Mosaic, 46 × 46 in. (117 × 117 cm). Naples National Archaeological Museum, Naples. Photo © Luisa Ricciarini/Bridgeman Images.

Frank Gehry (born 1929). *El Peix,* **1992.** Stainless steel, 184 × 115 ft. (56 × 35 m). Photo p. 20: © Ralf Roletschek. Photo p. 21: Rmashhadi/Wikimedia Commons.

John James Audubon (1785–1851). *American Flamingo,* **1838.** Hand-colored engraving with aquatint, 38 × 66 in. (97 × 66 cm).

Georgia O'Keeffe (1887–1986). *A Black Bird with Snow-Covered Red Hills,* **1946.** Oil on canvas, 35 × 48 in. (88.9 × 121.9 cm). © The Georgia O'Keeffe Museum/Artists Rights Society (ARS).

Tamas Galambos (born 1939). *Blue Owl,* **1995.** Oil on canvas, 43¼ × 43¼ in. (110 × 110 cm), Private collection. © Bridgeman Images.

***Athenian tetradrachma depicting the Owl of Athens,* 5th century BC.** Silver, 1 × 1 in. (2.5 × 2.5 cm), Private collection. Photo © Boltin Picture Library/Bridgeman Images.

Ana Maria Pacheco (born 1943). *The Turning World (I),* **2012.** Polychrome wood & mixed media, 14¾ × 11¾ × 3 ¾ (37.5 × 29.7 × 9.5 cm), Private collection. © Ana Maria Pacheco, Pratt Contemporary Art Limited.

Simon Stålenhag (born 1984). *Tyrannousaurus.* Digital painting, Dimensions variable. © Simon Stålenhag.

Audrey Weber (1898–1981). *Marine Turtle,* **(c. 1955).** Oil on canvas, 56¾ × 67 in. (144 × 170 cm). © Natural History Museum London/Bridgeman Images.

Crisp. *Street art in Bogota, Colombia,* **2015.** Spray paint, Dimensions unknown. © Crisp.

Chiriquí peoples. *Frog pendant,* **eleventh–sixteenth century.** Gold metalwork, 3⅝ × 3⅜ in. (9.2 × 8.6 cm), Metropolitan Museum of Art, New York; Gift of H. L. Bache Foundation, 1969.

Georges de Groot (born 1974). *At the Zoo — Reptile,* **2017.** Acrylic on canvas. 39½ × 47½ in. (100.3 × 120.7 cm). © Georges de Groot.

Maria Sibylla Merian (1647–1717). *Surinam Caiman Protecting Her Hatchlings from a Coral Snake,* **1719.** Engraving. Photo © GraphicaArtis/Bridgeman Images.

Kuba peoples. **Friction oracle:** *Crocodile (Itoom),* **c. 19th–20th century.** Wood, 3⅛ × 2¼ × 15¼ in. (7.9 × 5.7 × 38.7 cm), Metropolitan Museum of Art New York; Gift of the Estate of Bryce P. Holcombe Jr., 1989. Photo © Metropolitan Museum of Art, Art Resource, New York.